A Euclid Beach Park Album

James A. Toman

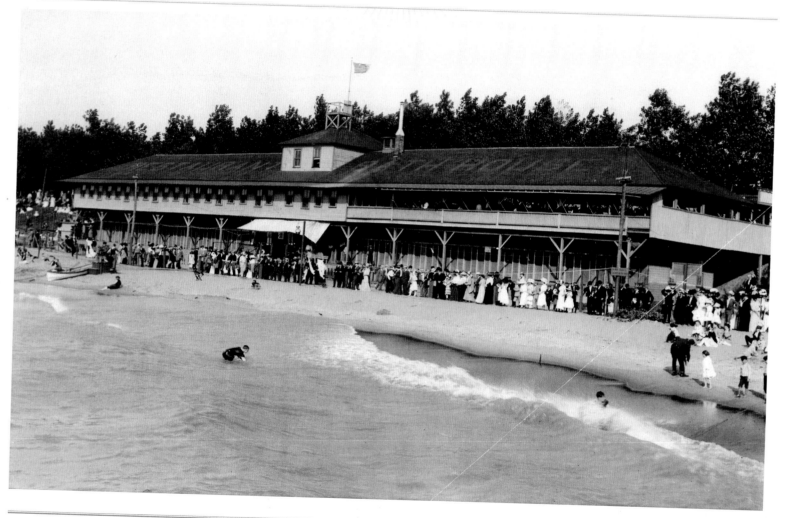

PUBLISHING INFORMATION

Published by
Cleveland Landmarks Press, Inc.
13610 Shaker Boulevard, Suite 503
Cleveland, Ohio 44120-1592

www.clevelandlandmarkspress.com

216 658 4144

ISBN–978-0-936760-29-2

Library of Congress Control Number: 201090985

Designed by:
John Yasenosky, III

Printed by:
Technical Communication Services
North Kansas City, Missouri

PREFACE & ACKNOWLEDGMENTS

It has been more than four decades since Cleveland's Euclid Beach Park closed its gates. The end came on September 28, 1969. Yet even after all these years, the memories of that wonderful place remain green (perhaps at least partially due to its being the predominant color at the park).

I give frequent talks on topics of Cleveland history, and Euclid Beach Park is one of the most requested topics. Inevitably at book events and signings, people inquire whether there are any books on the park available. That interest was key to putting together this album about the Beach.

Actually, the story of Euclid Beach Park has already been wonderfully told. In 1977, four Clevelanders – Lee Bush, Edward Chukayne, Russell Hehr, and Richard Hershey – wrote *Euclid Beach Park is Closed for the Season*. The book, well illustrated with maps, charts, and photographs, offered a complete history of the Beach. It found a ready audience, making the book a significant publishing success. Encouraged by the response, the authors in 1979 put together a sequel, *Euclid Beach Park: A Second Look*. It too met with a gratifying response. A third book, *Euclid Beach Park Yearbook*, by Blake LeDuc, Sr., appeared in 1996. It was a compendium of details relating to the park's operation.

So, why another Euclid Beach book? There are two reasons for doing so. First, the aforementioned books have long been out of print (although from time to time they are still available through the second-hand markets on Amazon.com and Ebay).

This book will hopefully fill a current vacuum, and may also be of interest to the inveterate Euclid Beach Park aficionado.

The second reason, however, proved more compelling. In 1969, Harry Christiansen, long-time reporter for the old Cleveland *News* and the region's foremost transit historian, turned his attention to Euclid Beach Park. It was to be the park's final year of operation, and Christiansen was determined to document in detail that last season. He took some 700 slides of the park during 1969 and also made return visits after the park had been closed.

Upon Harry's death in 1985, Morris Stone, vice chairman of American Greetings Corporation, purchased Harry's vast collection of transit and Cleveland-related photography, as well as dozens of scrapbooks of public transit historical documents and postcards, and donated the lot to Trolleyville, USA. Trolleyville, in suburban Olmsted Falls, Ohio, was Gerald E. Brookins' operating streetcar museum. The Christiansen collection found a home in the Trolleyville library.

When Trolleyville closed down in 2006, the collection became the property of its successor, the Lake Shore Electric Railway, which had plans to re-establish the museum in downtown Cleveland. Those plans faltered, and in 2010, the Lake Shore trustees donated the library's contents, known as the Gerald E. Brookins Collection, to the Special Collections Department of Cleveland State University's Michael Schwartz Library.

As CSU library personnel began the task of organizing the collection, the Euclid Beach slides once again saw the light of day, after having languished in obscurity for four decades. Sadly, about half of Harry Christiansen's Euclid Beach images had been ruined by a flood, but some 350 survived. I felt that those images, never before published, deserved a wider circulation. They now form the content of this album.

I am grateful to Harry Christiansen for his devotion to preserving Cleveland history, to Morris Stone for making sure that the collection survived, and to the trustees of the Lake Shore Electric Railway for their civic spirit in making sure that the collection would be permanently housed in a Cleveland repository.

I am also grateful to William Barrow, head of CSU's Special Collections, and to Lynn Duchez Bycko, for inviting me to work with the Brookins/Christiansen materials, and for their support in making them more broadly available through this publication.

I also thank my partners in Cleveland Landmarks Press, Dan Cook, Kathy Cook, and Greg Deegan for their support of this venture.

The photographs in this book are by Harry Christiansen, unless noted otherwise.

I hope that this album will rekindle happy memories of special times spent in wonderful old Euclid Beach Park.

James A. Toman
June 2010

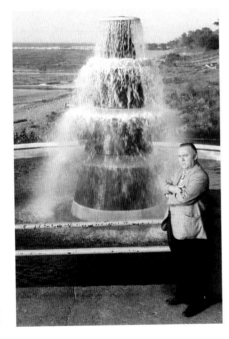

Harry Christiansen
at the Beach, 1969

Jim Toman at the Beach,
1969, *Charles Tuma photo*

INTRODUCTION

Nowadays there is a tendency to think that when it comes to amusement parks, "bigger is better." The 25,000 acres of Disney World in Orlando, Florida, is probably the first image that comes to mind. Closer to home, Cedar Point in Sandusky, Ohio, with its 17 coasters, bills itself as the roller coaster capitol of the world.

Cleveland's Euclid Beach Park was only a little over 75 acres in size, and it boasted of only four roller coasters, but its capacity to host visitors to an enchanted time was very great indeed. Perhaps there is more than a kernel of truth in another saying – that "size doesn't matter."

Euclid Beach Park was hemmed in between Lake Shore Boulevard and the Lake Erie shore line. It stretched east from East 156th Street to the property line of the Ursuline Sisters of Cleveland, site of the order's motherhouse and Ursuline Academy, about eight miles east of Cleveland's Public Square. Euclid Beach Park opened to the public on June 30, 1895.

A dance hall, a bath house, and a theatre building were almost the only attractions during that first year. Swimming, band music, and vaudeville acts were the bill of fare. At the eastern end of the park stood a tent city campground. The next year the park management added some rides and introduced games of chance and a beer garden.

Euclid Beach Park's glory years began in 1901 when Dudley S. Humphrey II, who had achieved business success with his popcorn concessions, bought the park from its initial owners. He declared that under Humphrey management the park would be a place to bring the whole family. Only what was "wholesome" would be on the agenda. The Humphreys banished beer consumption, the tacky side shows, and the games of chance, and they employed a park police force to enforce the rules which they put into place to assure social decorum. Under the Humphreys, a new era had begun.

The first decades of Humphrey management brought a steady stream of improvements to the park. By the onset of the Great Depression, most of the features that would remain to the park's last day were already in place. Visitors could take in the high rides (Aero Dips, Thriller, Racing Coaster, Flying Turns); the Mill Chute (later to be rebuilt as the Over the Falls); the Colonnade with its kiddie rides and the neighboring Sleepy Hollow Railroad; the Racing Derby and the Carrousel (in Euclid Beach spelling, the word had a double "r"); the skating rink; penny arcade; Dodgems, Bug; and, of course, the lunch areas and refreshment stands.

Other rides would continue to make their appearance. Patron favorites, like the Laff in the Dark, Surprise House, Flying Scooters, Rocket Ships, Dippy Whip, and Bubble Bounce (later replaced by the Rotor) were soon added to the midway. Even as the park entered its last decade of existence, improvements continued. A new Turnpike ride opened just northwest of the Rocket Ships, an Antique Auto ride was housed in the former skating rink, and the Coffee Break replaced the Dippy Whip.

Euclid Beach Park was a popular destination not only for family and individual outings, but it was also a very successful venue for annual company and school picnics. Both the Cleveland *Press* and *Plain Dealer* sponsored picnics there. Many prominent Cleveland companies, like Cleveland Trust; the Bailey, Higbee, and May Company department stores; Cleveland Twist Drill; Richman Brothers; Printz-Biederman; and Cleveland Pneumatic Tool, held annual picnics at the Beach. Like Euclid Beach Park itself, these mainstays of the Cleveland economy would before long also become only historic references.

Euclid Beach Park set its all-time attendance record in 1945, and the park remained profitable until 1962. In its last years, however, losses needed to be trimmed. Sacrificed to the bottom line were the Aero Dips in 1965 and the Racing Derby (sold to Cedar Point) in 1966. In 1967, in order to raise cash and lower tax bills, park management sold Humphrey Field, the baseball diamonds across from the park on the south side of Lake Shore Boulevard.

While to its Greater Cleveland patrons, Euclid Beach Park seemed a permanent fixture on the local scene, it was, after all, a business, and The Humphrey Company could not sustain losses indefinitely. In 1968, Beach officials announced that 1969 would be the last year for park operations, and that they had granted Associated Estates an option for a 47-acre parcel, the area of the park west of the 25-acre campgrounds. Associated Estates announced plans to build apartment buildings on the site.

The last day for Euclid Beach Park came on September 28, 1969.

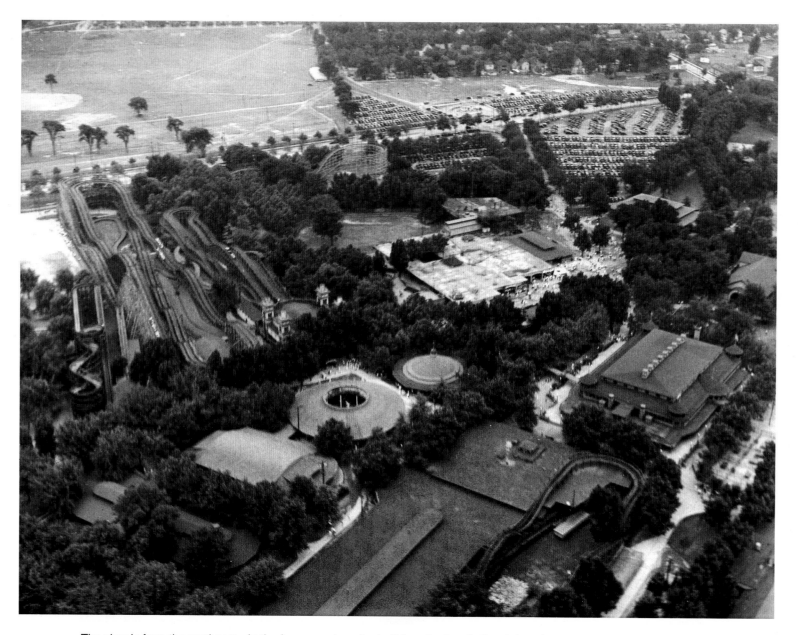

The view is from the northeast. In the foreground are the buildings for the skating rink and penny arcade. The Aero Dips
roller coaster is to the right. At the top of the photo, across Lake Shore Boulevard is Humphrey Field and the overflow parking lot.
Robert Runyon photo, Bruce Young Collection, Special Collections, Cleveland State University Michael Schwartz Library

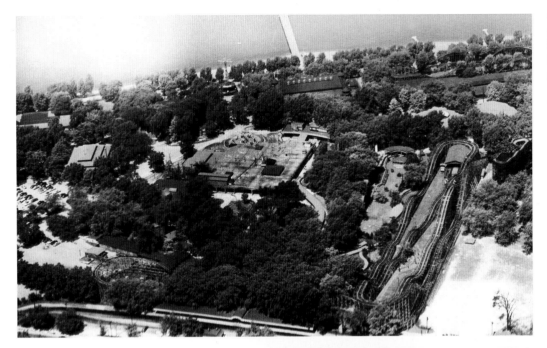

View is from Lake Shore Boulevard. In the center is the Colonnade, headquarters for the kiddie rides. At the top of the photo, the pier juts into Lake Erie. *Robert Runyon photo, Bruce Young Collection, Special Collections, Cleveland State University Michael Schwartz Library*

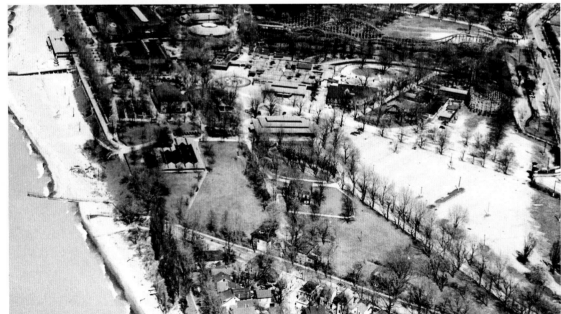

This 1949 aerial shows the park from the west. East 156th Street is at the bottom of the picture, and Lake Shore Boulevard is to the right. *Robert Runyon photo, Bruce Young Collection, Special Collections, Cleveland State University Michael Schwartz Library*

Most people think of the famous Euclid Beach arch, designated a Cleveland historical landmark in 1973, as the main entryway to the park. The arch entrance, however, really played a secondary role until the 1950s and 1960s. The arch entrance only served visitors arriving at the Beach via private automobile.

During the beginning years and for the first several decades after that, public transportation was the chief means of getting to the Beach. When the park opened in 1895, passenger ferries traveled between a dock on the Cuyahoga River in downtown Cleveland and the Euclid Beach pier.

After the Humphrey family took over the park in 1901, the ferry service was discontinued, and the streetcar became the chief transit link to the park. Passengers could reach the park from three Cleveland Railway Company lines, Euclid, Superior, and St. Clair. The latter was the most direct, and carried the most passengers to the Beach. A trip to or from downtown on the St. Clair line took 56 minutes. Service from Lake County was via the Cleveland, Painesville and Eastern interurban line.

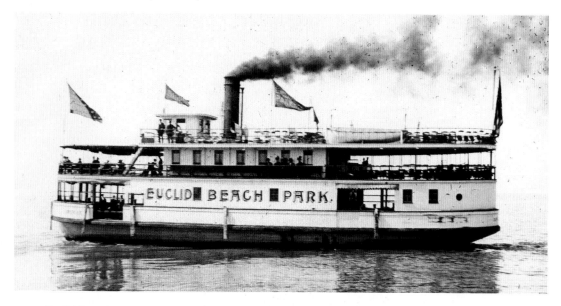

Euclid Beach owned two ferries which brought visitors from downtown Cleveland to the park.
Bruce Young Collection, Special Collections, Cleveland State University Michael Schwartz Library

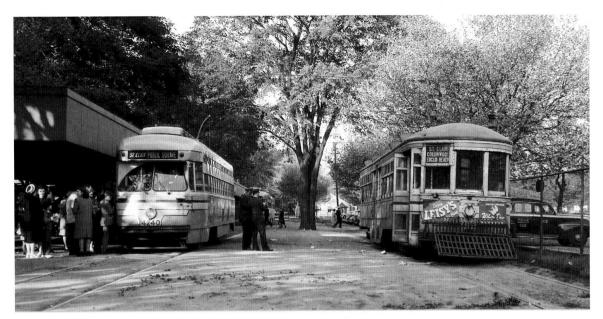

Euclid Beach had a double-tracked streetcar loop to provide the level of service required for such a busy destination. In 1947, after a day of fun, passengers board a streetcar for the trip home. *Bill Vigrass photo*

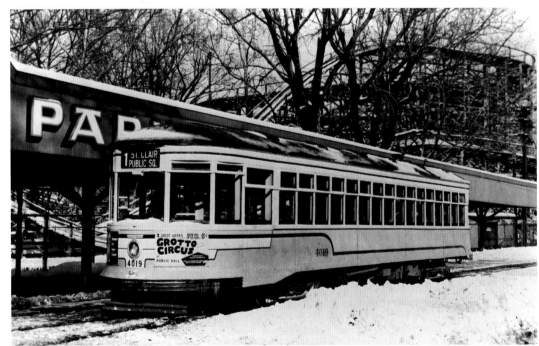

In winter 1950, with the park closed for the season, the snowy Euclid Beach loop is a quiet place. *Jim Spangler collection*

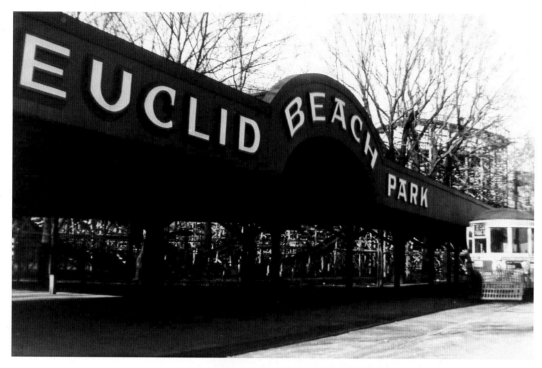

Streetcar passengers entered and departed the Beach through an arched sheltered passenger waiting platform, an arrangement especially welcome on rainy days. *Jim Spangler collection*

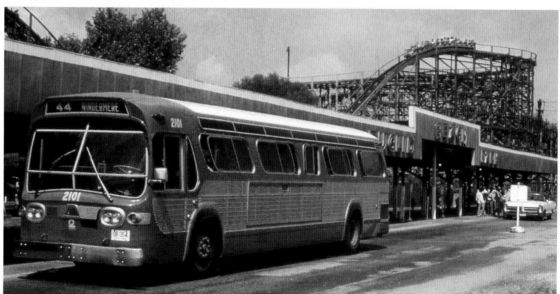

Streetcar service to Euclid Beach ended in April 1951. After that, transit users had to take the bus.

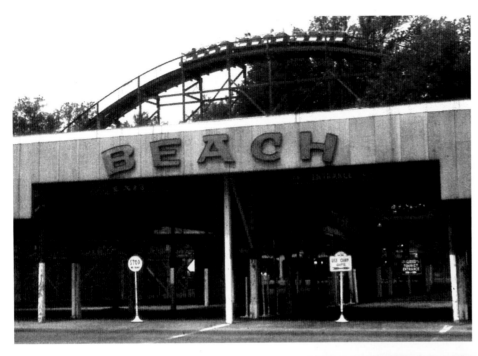

The transit entrance to the park was modernized during the bus era. From this portal, passengers followed a covered pathway to the midway.

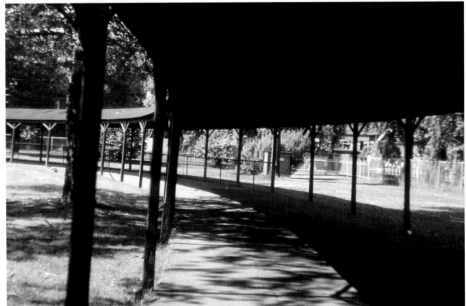

This covered walkway led from the transit entrance to the Colonnade building. From there it also stretched to the main refreshment stand and then beyond to other sheltered attractions that could continue to operate even when it was raining.

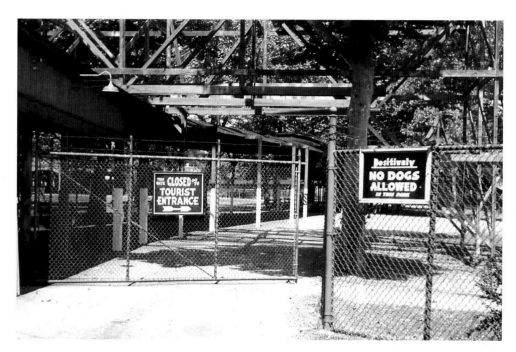

When the park gates were closed, there was still one more option for gaining access to the site. A sign directs visitors to the guarded campground entrance farther east.

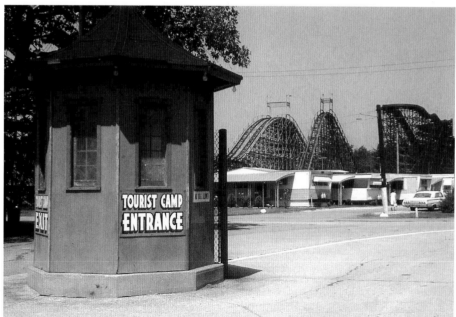

A guard kiosk stands at the entrance to the campground. The campground occupied 25 acres at the eastern end of the Euclid Beach property.

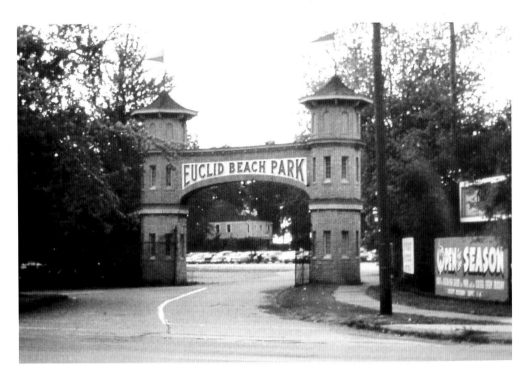

Eager Euclid Beach fans always kept their eye out for the sign announcing the opening of the park for the season. In 1969 the sign made its final appearance.

Old-time autos thread their way through the Euclid Beach arch and into a nearly full parking lot.
Bruce Young Collection, Special Collections, Cleveland State University Michael Schwartz Library

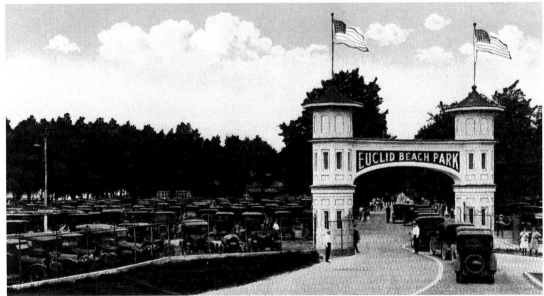

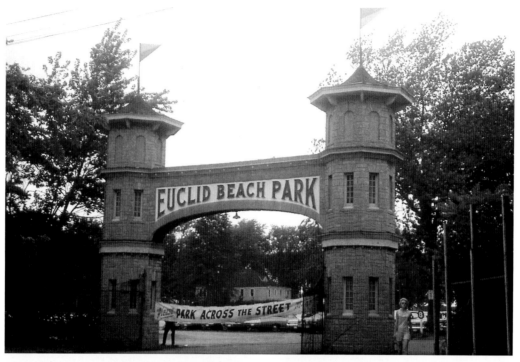

Posting the banner to park across the street was a pleasant task for park workers. It meant that a good crowd was in attendance.

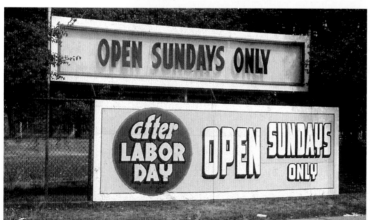

When this sign went up on the Euclid Beach fence, patrons knew that the end for park was near. After Labor Day, which fell on September 1 in 1969, the park would only be open four more days.

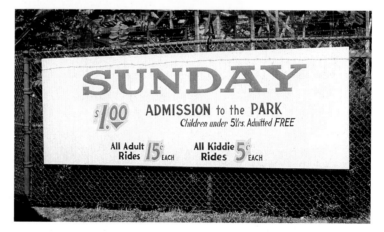

A "free gate" had long been a hallmark of Euclid Beach operations. As revenues began to slide and costs to rise, however, park management found it necessary to adopt a modest $1.00 admission fee for Sundays.

SWIMSUITS & DANCING SHOES

Before Euclid Beach Park installed rides, it still had popular attractions. It was blessed with a sandy Lake Erie beach. At the sand's edge, park owners built a combination bath house and restaurant facility. A long pier provided an inviting spot for the angler, and at the top of the bluff, overlooking the lake, park officials positioned a large dance hall. These were sufficient in the early years to draw substantial crowds.

Over the years, Lake Erie's tempestuous winters eroded the beach and battered the pier. The lake's appeal for the swimmer and fisherman declined. But up above, on the bluff above the lake's edge, a sycamore-shaded walkway continued to provide an enjoyable view of the lake, particularly as the sun began to set. The dance pavilion remained a popular venue for many years, although after 1959 it operated only when an organization reserved it in advance.

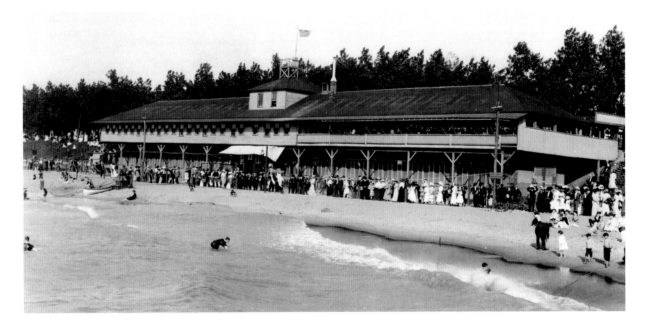

Only a few hearty souls are testing the Lake Erie waters. Most are content to be observers. This well-dressed crowd most likely has gathered for lunch in the second-floor dining room. The faint lettering on the roof of the building spells out "restaurant" and "bath house." *Bruce Young Collection, Special Collections, Cleveland State University Michael Schwartz Library*

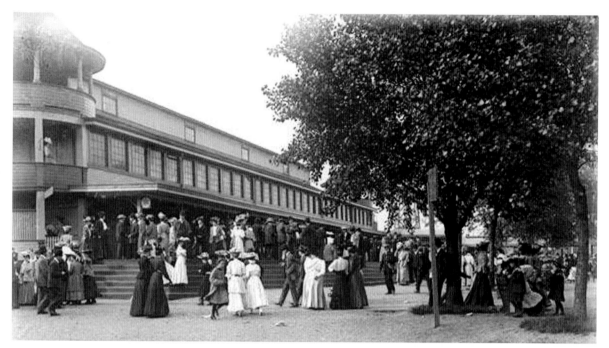

This early view of the Euclid Beach dance pavilion shows women in long dresses and men in suits and ties as they wait for the hall to open. The style of dress was partially dictated by the conventions of the time and by the waltz music that predominated in the hall, but it also reflected the Humphreys' strict dress code. *Cleveland Memory, Special Collections, Cleveland State University Michael Schwartz Library*

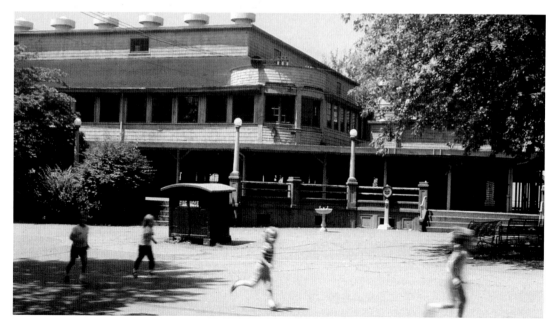

The spacious dance pavilion boasted a floor of 18,000 square feet, making it one of the largest dance halls in the country.

The dance pavilion featured a surrounding outdoor promenade. In an era before air conditioning, it was particularly welcome to dancers, a place where they could enjoy the breeze off Lake Erie between dances.

This spacious patio was located to the north of the dance pavilion. Originally it was intended for outdoor dancing, but eventually became the locale for ping pong tables and shuffle board courts. The patio has survived the park's closing, and the faint outline of the shuffle board layout can still be seen.

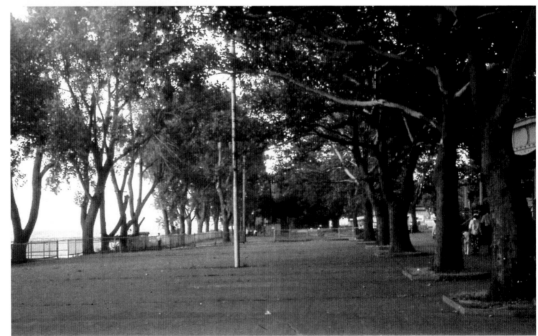

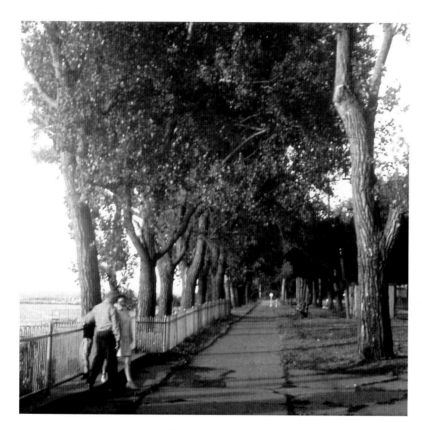

Another remnant of Euclid Beach Park which survives is the tree-lined walkway at the top of the bluff. This view looks east.

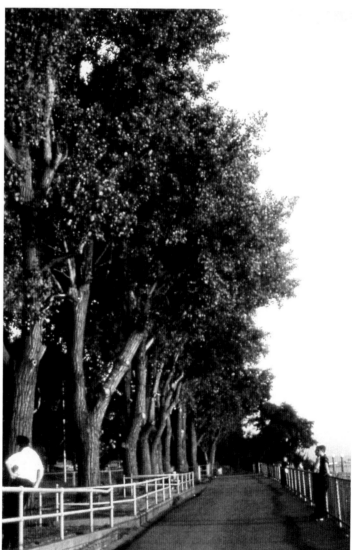

This view of the lakefront walk is to the west. A number of the park's green metal benches were spaced along the way, providing patrons a pleasant location to rest between rides and games.

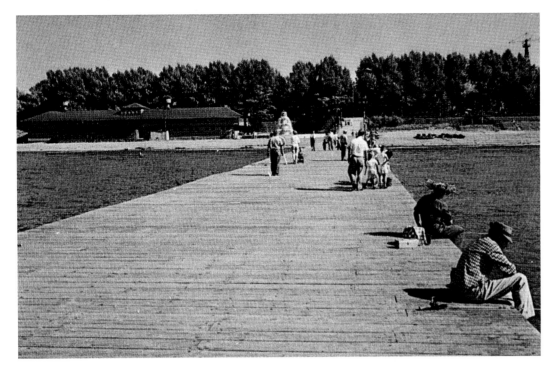

The Euclid Beach pier was originally built as the dock for the passenger ferries which brought patrons to the park from downtown Cleveland. As this postcard scene illustrates, it was also a spot to try one's luck at fishing. *Bruce Young Collection, Special Collections, Cleveland State University Michael Schwartz Library*

Originally the pier extended 550 feet into Lake Erie. Winter ice, however, annually took its toll, and each spring park workers spent considerable time and money to restore it. As revenues dipped, such maintenance became prohibitive. In this 1969 scene, only a truncated portion of the pier remained. It remains in place to the present time.

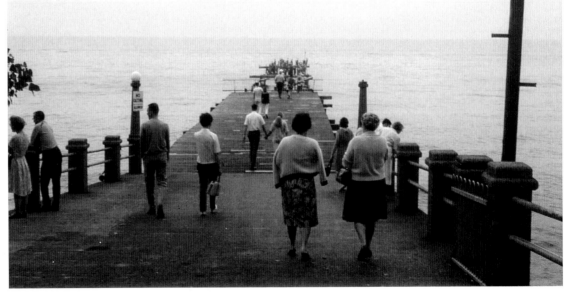

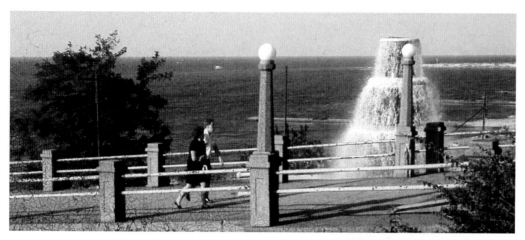

The southern-most portion of the pier was lighted and made of concrete. The fountain, at the pier's southern end, was built in the center of what had originally served as a wading pool and then after that the foundation for the Sea Swing ride.

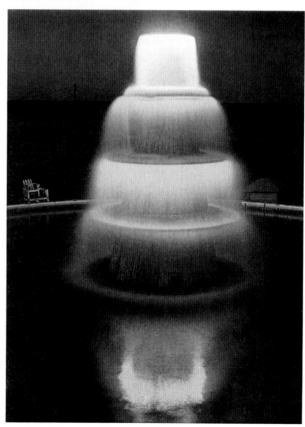

The fountain shone brightly at night. Colored lights were reflected by the cascading water. The fountain is now gone, but the circular concrete pool in which it was centered has survived, now filled with beach sand. *Postcard from the Bruce Young Collection, Special Collections, Cleveland State University Michael Schwartz Library*

LUNCH TIME

For many families, a picnic lunch was a key element during their visits to Euclid Beach Park. This practice was especially common with people spending an entire day at the Beach as part of a company-sponsored outing. Families would arrive at the park, laden with picnic baskets, hampers, and coolers.

Once at the park, visitors could secure their claim to a preferred lunch table simply by stationing their baskets on it. They had their choice of indoor or outdoor lunch areas. The Beach had over 2,000 tables in various locations from which to choose.

Not all visitors went to the trouble of packing their lunches. Some found it more convenient to visit one of the park's lunch counters, located at the Lake Lunch pavilion at the western end of the park, at the Colonnade, or at the Main Lunch, located just north of the Penny Arcade. Hot dogs, ham sandwiches, and pies of several flavors were patron favorites.

If one simply wanted a snack or beverage, the main refreshment stand and the frozen whip stand were conveniently located near the center of the midway.

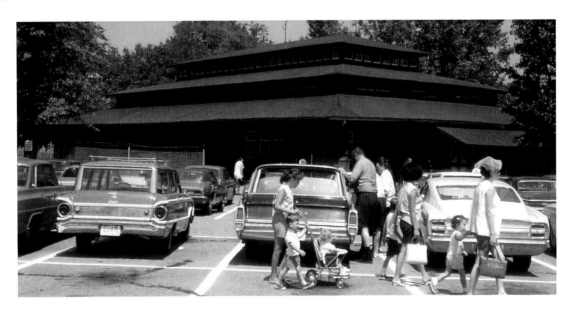

The Log Cabin was frequently the first stop for patrons at the park for a company outing. The Log Cabin was used as "picnic headquarters," and it was where people could pick up badges or specially priced tickets.

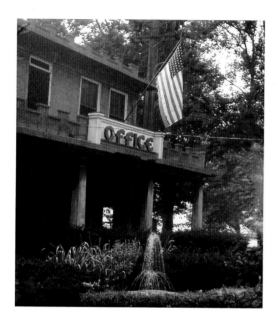

Few patrons paid much attention to the Office. It was the park management's nerve center for operations.

The Lake Lunch, located at the western end of the park and near the bluff, was the Beach's largest covered lunch area. It housed rows of tables and a refreshment counter. Many patrons found the delicious Euclid Beach blend of hot coffee served there particularly welcome when stiff winds came off the lake.

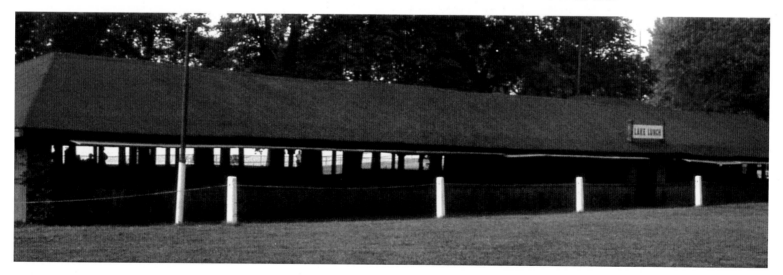

The extensive lawn area south of the Lake Lunch pavilion was the scene for the games and contests conducted at many company picnics.

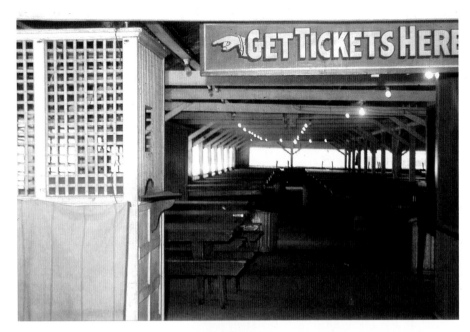

Successfully maneuvering through Euclid Beach Park required a pocketful of tickets, rather than cash. Even food was priced in number of tickets.

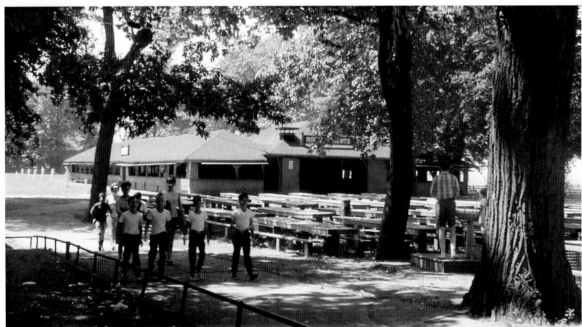

Another open picnic area was located just east of the Lake Lunch pavilion.

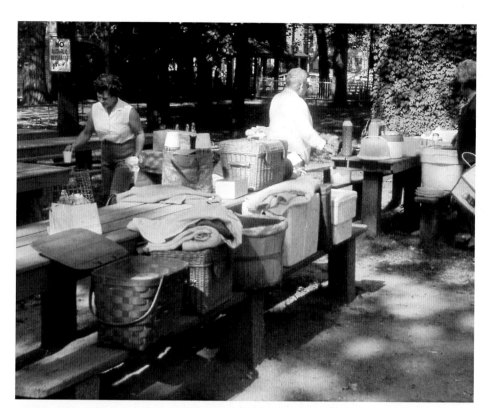

top left:
These lunch tables have been claimed. It doesn't seem likely that those dining here would have gone hungry.

bottom left:
Ticket booths, painted in a bright shade of yellow, were situated throughout the park. Tickets, costing five cents each, were dispensed by machine, often in strips of five.

bottom right:
The park's main refreshment stand was located in the center of the midway, just opposite the Colonnade.

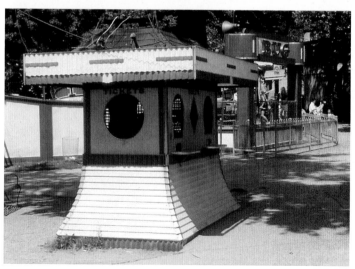

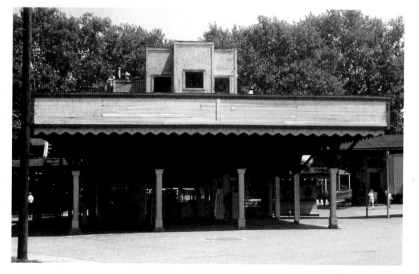

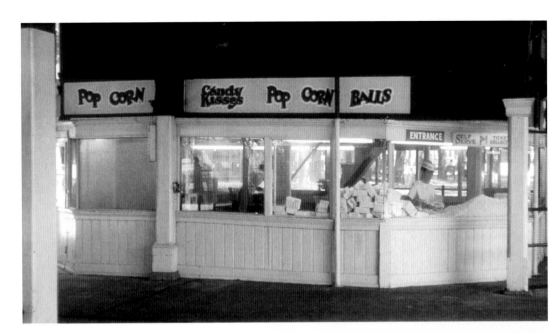

The refreshment stand served four Euclid Beach favorites: peanuts, popcorn, popcorn balls, and taffy kisses. The popcorn and kisses are still produced by The Humphrey Company and are available in most supermarkets.

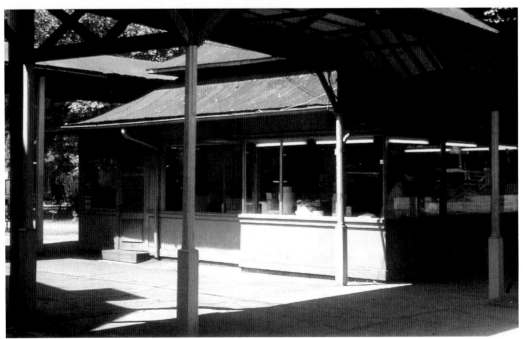

The taffy kisses were made right in the refreshment stand, and visitors could watch the confection being stretched, cut, and wrapped.

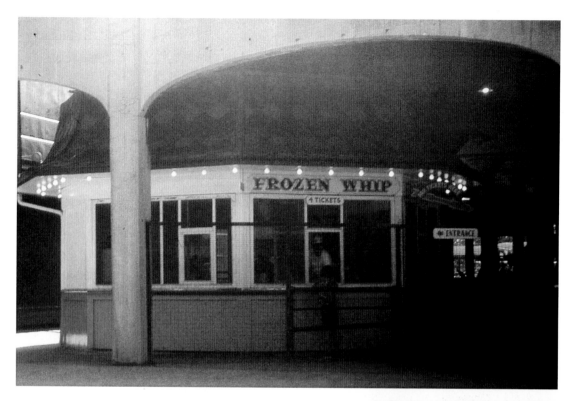

Another Beach favorite was a delicious frozen whip, a frozen vanilla custard served in a sugar cone. The frozen whip stand was located in the northeast corner of the Colonnade, just across from the main refreshment stand.

For many years cold beverages were served at a counter in the refreshment stand. In the early years of the park, loganberry juice was the signature drink. Later years saw root beer and ginger ale as the favorites. In the park's last years, it became more economical to dispense drinks from vending machines.

I t was the accepted wisdom of the 1950s and 1960s that one should not get on the park rides with a full stomach. "You'll get sick" was the warning that parents gave to their children, chomping at the bit for some exciting ride action.

Adults believed that a period of sedate activity was called for to allow the digestive process to take its proper course. So it was that many would tour the midway, planning their riding strategy, and perhaps taking in a couple of the park's more settling attractions.

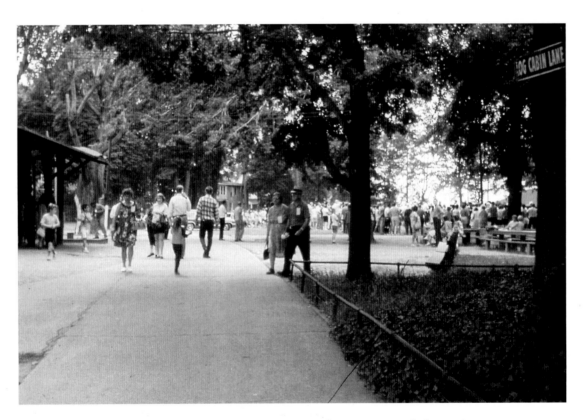

A couple leaves the picnic grove area and saunters towards the east.
That's where the action could be found when the time was ready.

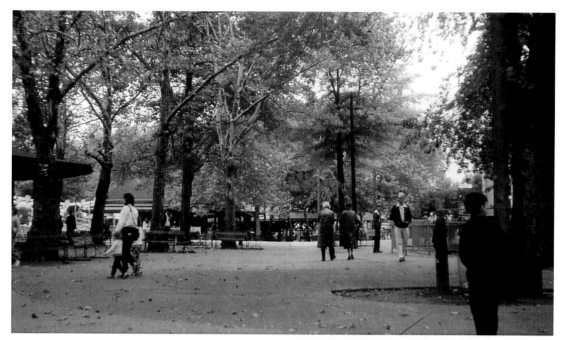

A walk through the shady midway of the Beach was always pleasant. If one wanted to rest a bit and contemplate, the park's standard green metal benches were readily available.

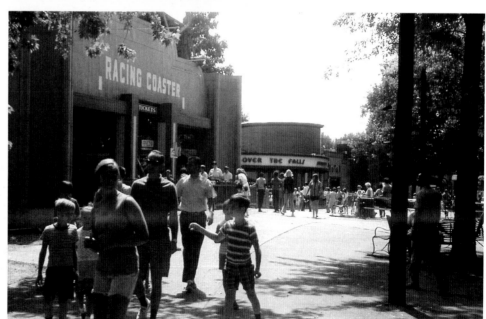

As a family passes the Racing Coaster, something about the Thriller catches the attention of the young boy.

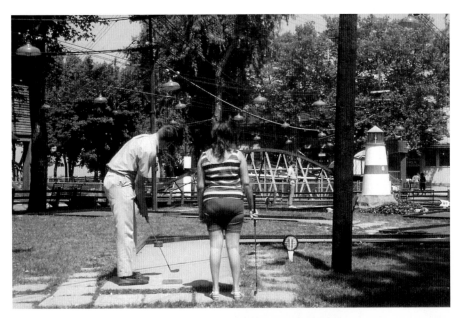

Perhaps a round of Pee Wee golf was in order before the more intense stimulation of the rides. The 18-hole miniature course was located just south of the Bug ride.

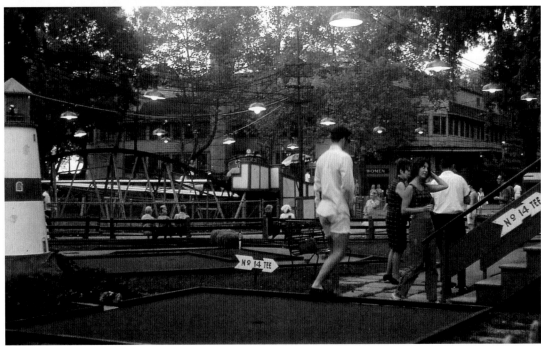

The miniature golf course was bisected by a pathway. Golfers needed to cross over an archway to reach the second half of the layout.

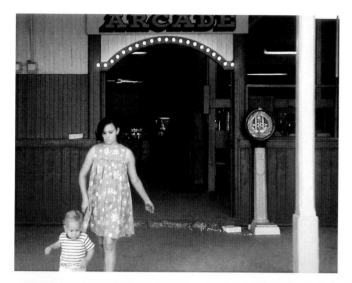

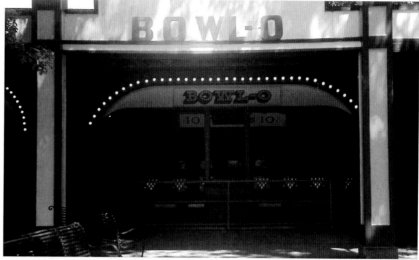

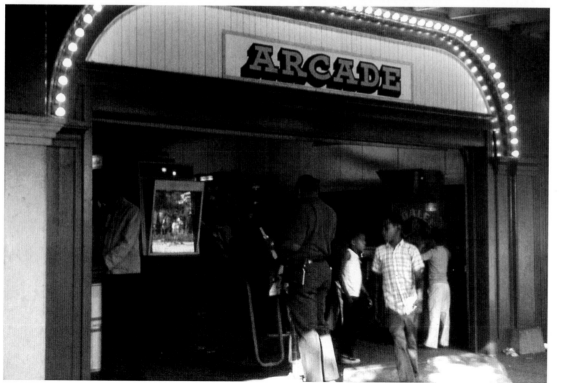

top left:
Another bit of relatively quiet time could be spent in the Penny Arcade. Here the little one seems to have had his fill of the game room, as he leads his mom to another adventure.

top right:
The Bowl-o games were among the newer items of Arcade equipment. The Arcade was one of the few places in the park where cash, rather than tickets, was used.

bottom left:
The Arcade offered a variety of games, from the popular claw machines and pinball games, to skill games such as baseball and target shooting. The Arcade even had a fortune-telling machine.

Skee Ball had its own game room, adjoining the Colonnade. The games came in both long and short dimension formats.

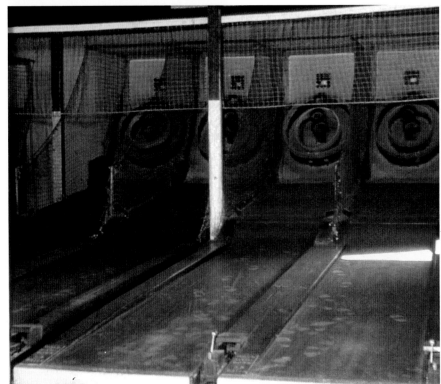

Skee Ball was another place where money, instead of tickets, could be used. These long skee ball alleys offered nine balls for a nickel. In keeping with Humphrey policy against gambling, the games did not offer prizes, just the satisfaction of getting close to the top possible score of 450.

THE RIDES

While Euclid Beach Park had a variety of appealing attractions, most people came to the park for the rides. Over the years, rides came and went, the Humphreys each year intent on providing a new and more satisfying experience for their patrons.

In 1969, the park's last year of operation, there were 18 adult rides/attractions (the total includes the Surprise House) and another 11 for kiddies. When one includes the Sleepy Hollow Railroad, popular with both adults and children, the total came to 30.

The oldest ride in the park was the Carrousel, dating from 1910. Several rides were added in the Beach's final decade: the Turnpike, Antique Autos, Coffee Break, Tilt-a-Whirl, Ferris Wheel, and the Scrambler.

While individuals might debate which ride was the best in the park, the longer lines of patrons waiting to board one of the roller coasters give evidence that the high rides had earned the title of overall favorites.

The following album pages start with the rides at the western end of the park and move toward the east.

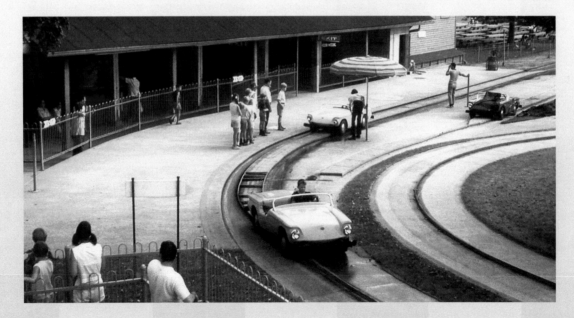

The Turnpike, built just north of the old Theatre Building and west of The Bug was one of the park's newest rides. It was added in 1962.

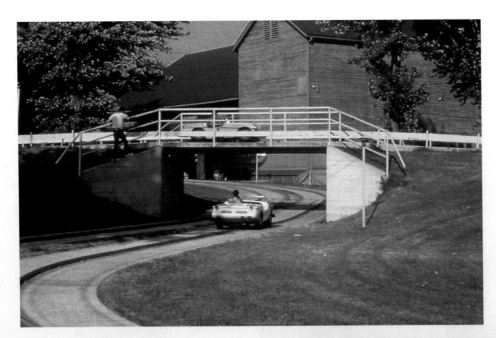

The Turnpike course was a figure-eight design. After the Beach closed, the crossover bridge in the center of the photo survived the bulldozer. It remains to the present, an isolated relic of the grand old park.

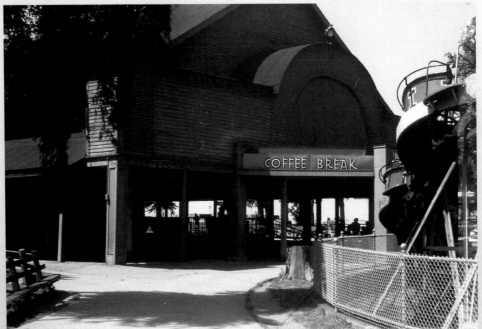

The spinning Coffee Break ride replaced the Dippy Whip in 1964. Its building had originally been the home of the Euclid Beach Theatre.

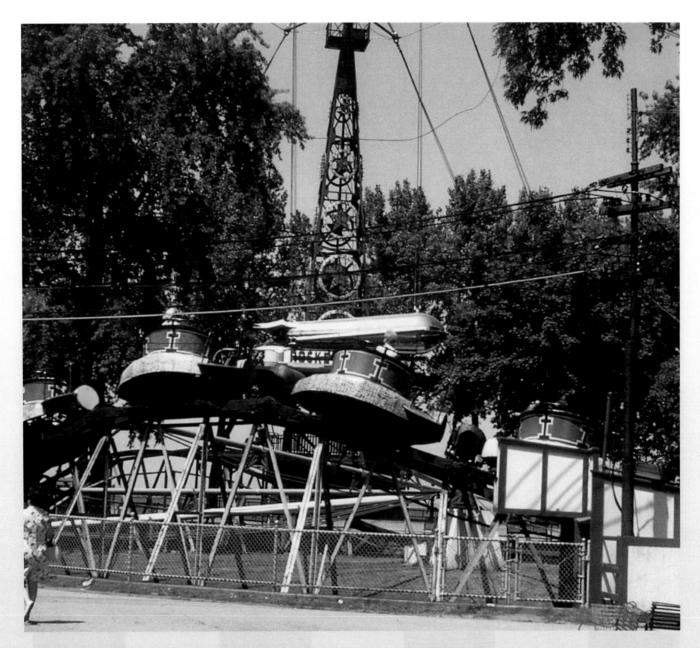

The colorful Bug was not unique to Euclid Beach. Its small hills and dips packed a wallop,
jolting its passengers into one another with a force that defied opposition.

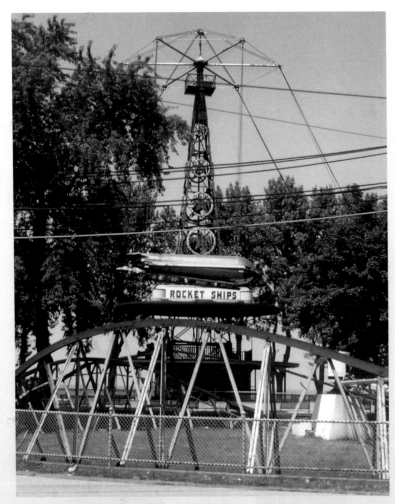

The Rocket Ships ride looped its passengers calmly above the park, offering excellent views of the lake and the midway.

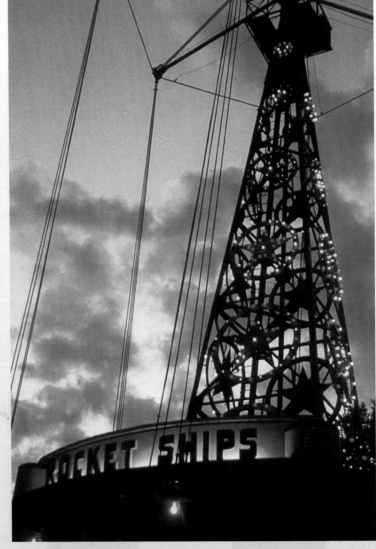

As darkness fell, the lights of the rocket ships' central tower came on, giving the ride a beckoning silhouette.

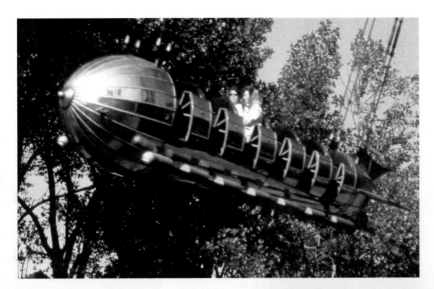

Two passengers have a rocket ship all to themselves. They buzz by the lakeside grove of sycamores, which were regularly pruned to give the rockets adequate clearance.

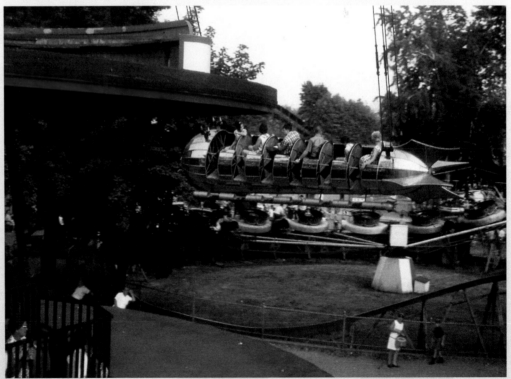

As the sleek rocket ships circled above, passengers waiting for the next trip stood on the stairway to the boarding platform. While they waited, they were treated to tunes from the programmed organ at the base of the building.

The multi-color "butterflies" flitting through the air were part of the Flying Scooters ride. Just east of the Scooters was the main refreshment stand.

The Flying Scooters had a special appeal for riders who wanted some "control" over their experience. A handle on the front wing allowed each rider to adjust the trajectory of the unit as it circled through the air.

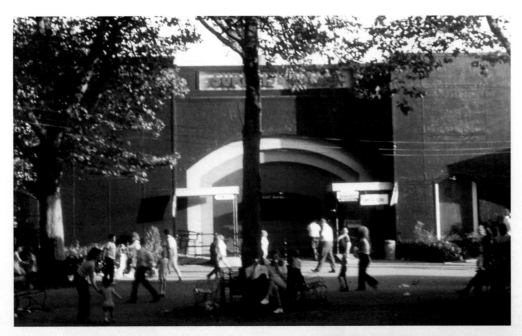

The Surprise House, called the "Fun House" by most park visitors, was filled with challenging features, such as moving walkways, tilted rooms, and air jets placed in the floor throughout the building.

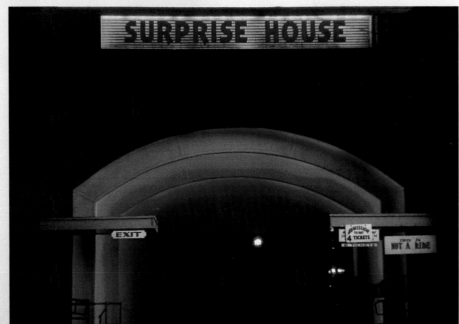

This view of the Surprise House at night carries an interesting sign. On bargain days at the Beach, admission to adult rides cost three tickets. The sign stipulates that the Surprise House is *not* a ride, though it still offered a bargain entrance fee of four tickets instead of the usual six.

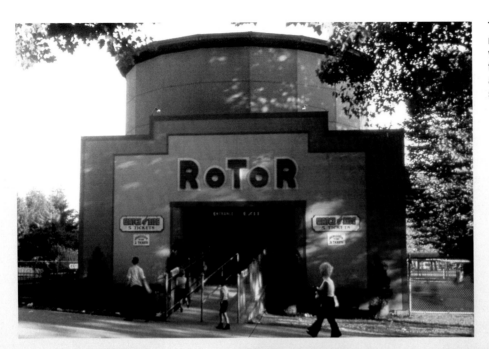

The gravity-defying Rotor came to the park in 1957, replacing the Bubble Bounce. Riders stood in a drum, with their backs against an adhesive-type surface. As the centrifugal force built up, the floor would drop away and the riders would be glued to the wall. As the ride slowed down, they would slowly slip back to the floor.

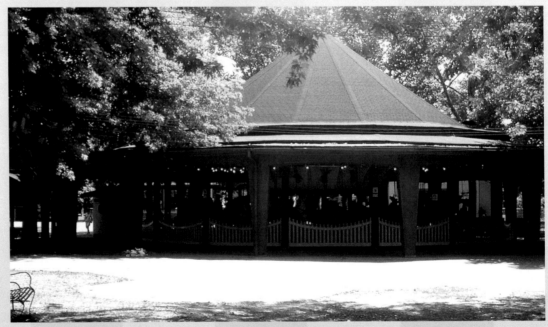

The Carrousel spun merrily under a sheltered dome, allowing the ride to operate even in inclement weather.

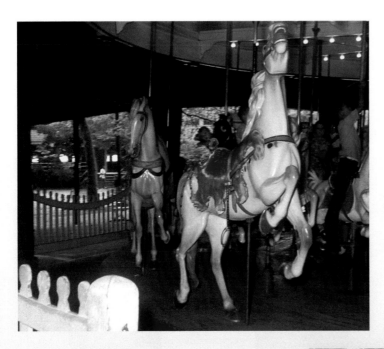

Some of the Carrousel horses were stationary, while others moved gently up and down to the music generated by the band organ situated at the center of the ride.

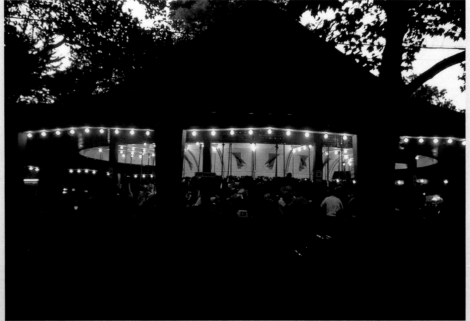

The well-lighted Carrousel circled on as night fell. After Euclid Beach closed, the ride was sold to a Maine amusement park. After that park closed, in 1997 the ride made its way back to Cleveland, where it will be reaassembled and displayed at the East Boulevard campus of the Western Reserve Historical Society.

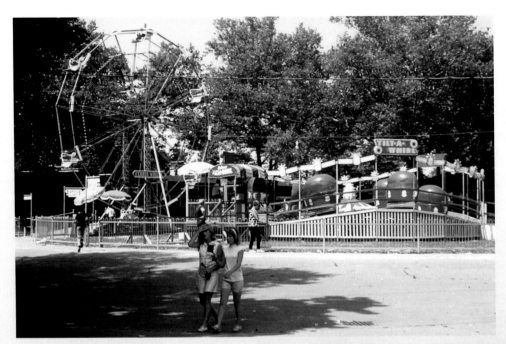

The Tilt-a-Whirl and Ferris Wheel stand where the horses of the American Racing Derby once roamed. In 1966, in a cost-conscious move, Euclid Beach officials sold the popular Derby to Cedar Point. It was replaced by these two carnival-type rides.

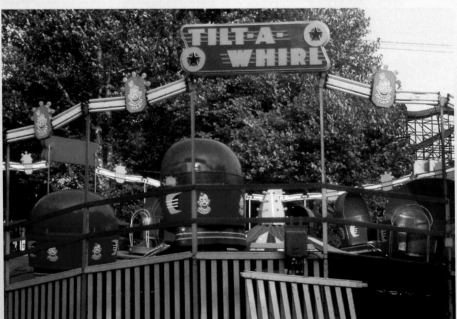

The Tilt-a-Whirl seats are empty as workers go beneath the ride to make repairs.

As night comes on, so do the lights on the Ferris Wheel and the Tilt-a-Whirl.

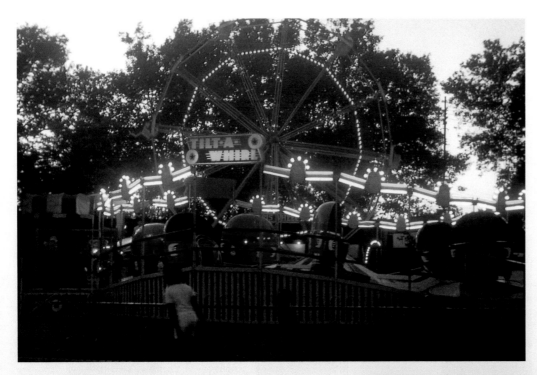

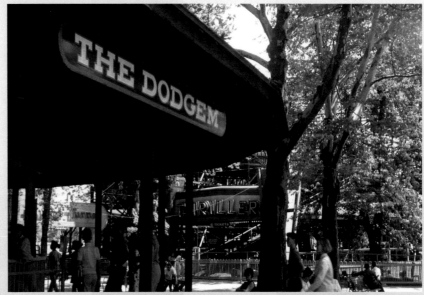

One didn't have to have a driver's license to board a Dodgem car. Of course, the way many young drivers maneuvered their Dodgems would surely have led to any such license being revoked.

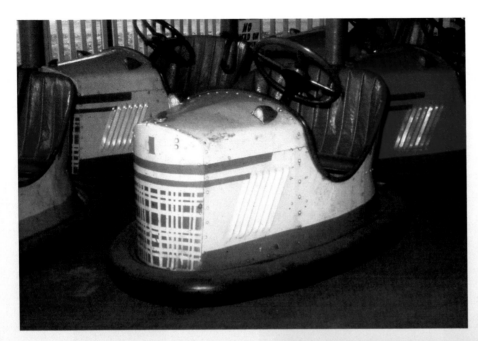

The seats of the Dodgem cars were padded, but that did not help one's knees when getting rocked by the driver of another car intent on engineering a hit to remember.

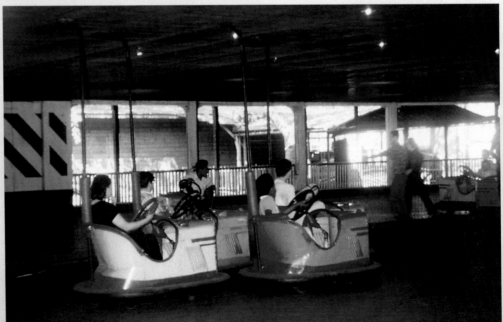

Dodgem cars were powered by being connected to an overhead electric grid. Once the gate opened, there was always a rush to claim a car. Here a couple heads for an available unit, while others wait for the power to come on.

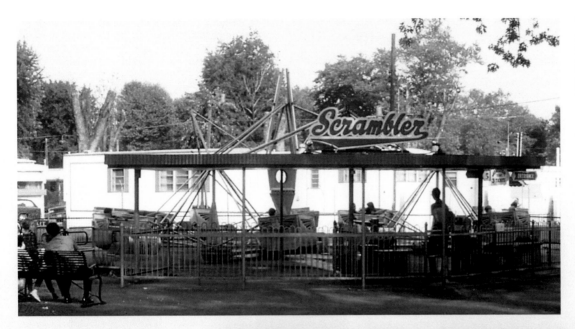

The Scrambler was one of the park's newest rides. It replaced the Rock-O-Plane at the eastern end of the midway. The territory of the Euclid Beach Campgrounds/Trailer Park began just beyond the ride.

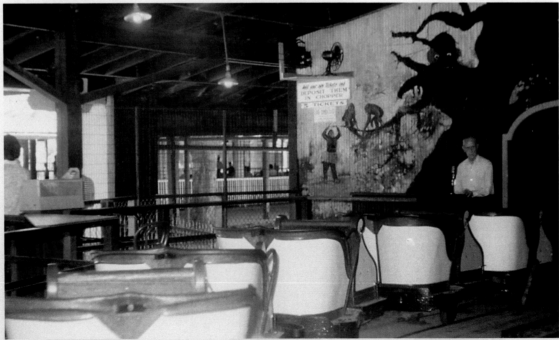

Empty cars await passengers for a trip through the Laff in the Dark. The scary painting at the entrance hinted at the "treats" that awaited the passengers.

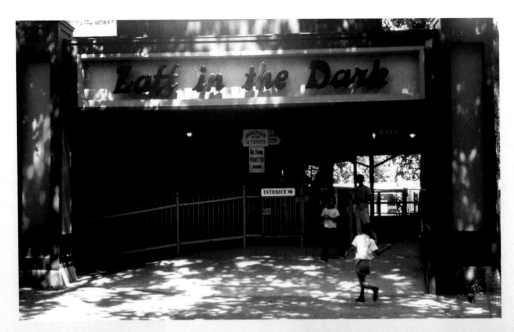

The Laff in the Dark could just as easily have been named the "Scare in the Dark." The ride route was in complete darkness, except for frightening things that would suddenly pop out. Probably the favorite feature of the ride was passing through a rotating star-painted barrel which made it seem as though the car was climbing up the side of the wall.

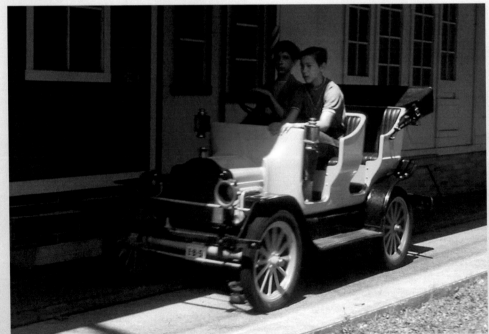

The Antique Autos were installed in the park in 1964. Their route was through the building that had long been home to the roller skating rink.

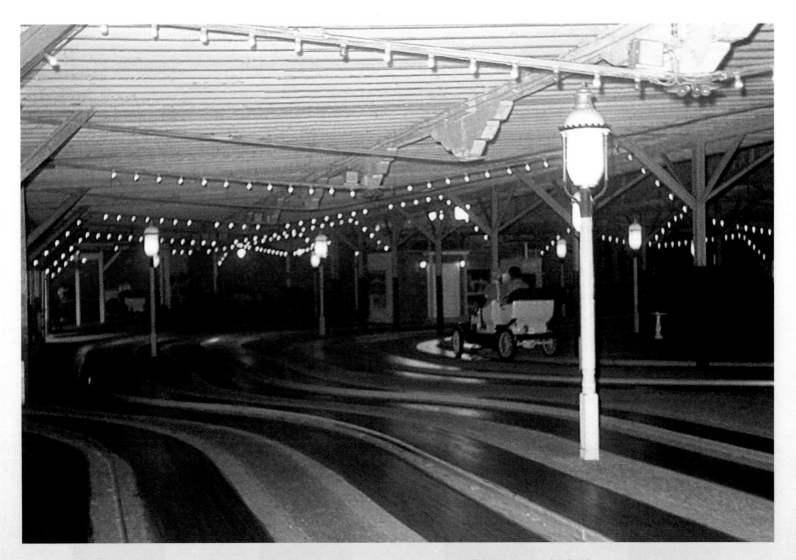

Though the Antique Autos ride was new, its course still bore the unmistakable imprint of the former roller rink which had operated there since 1904.

HILLS AND THRILLS

In its last year, Euclid Beach Park offered its guests four "high rides."

Three were roller coasters, the Racing Coaster, the Thriller, and the Flying Turns. The fourth was the water ride, Over the Falls. These four were lined up on the southern side of the midway, near its eastern end.

One other roller coaster had been razed in 1965 to save the cost required for its upkeep. The Aero Dips, the Beach's longest operating roller coaster, had been built in 1909. Its location was on the opposite side of the midway, just north of the Penny Arcade.

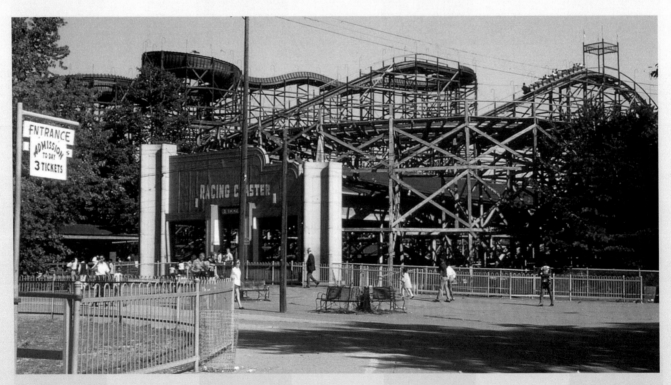

The view shows the park's three roller coasters. In the center, a Thriller car mounts the first hill. In addition to the thrills they offered, the wooden coasters possessed a certain inherent beauty.

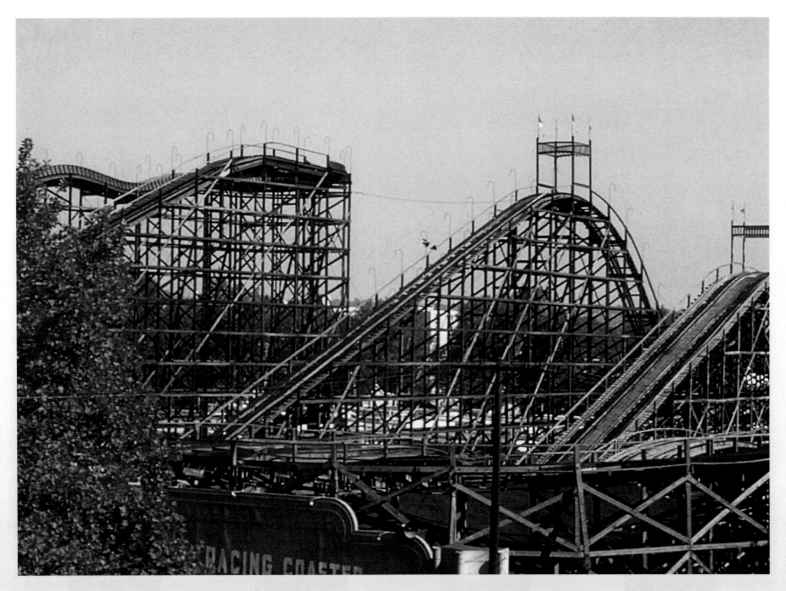

Taken from the upper level of the Dance Hall, this view shows the starting hills of the three roller coasters, the Flying Turns on the left, the Thriller in the center, and the Racing Coaster on the right.

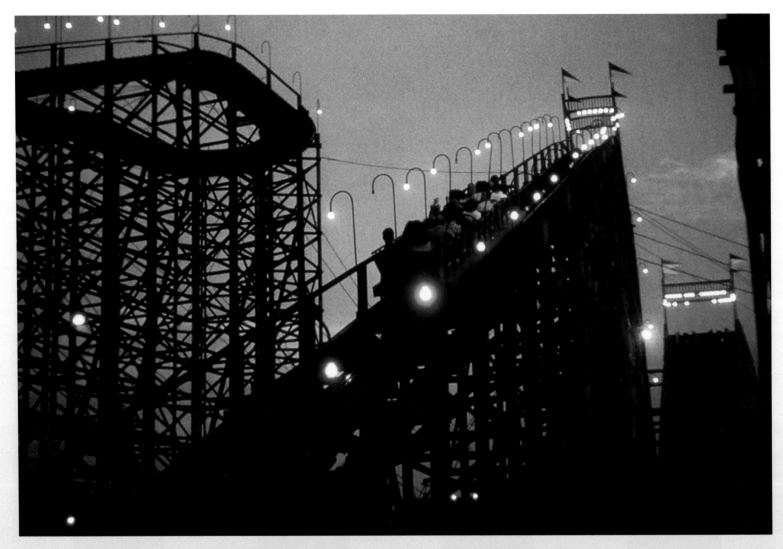

Lights mark the ascent of a Thriller car. Once the car hit the top of the hill, it would plunge into darkness.

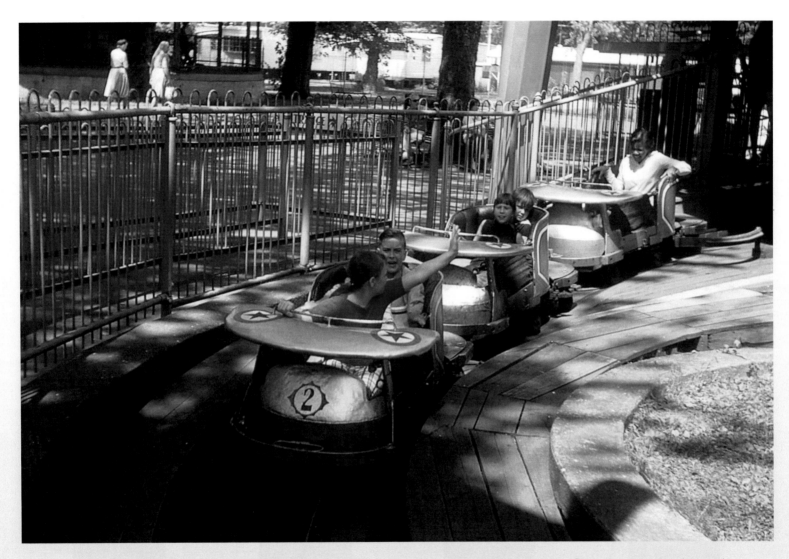

A three-car Flying Turns train glides to the chain that will pull it to the top of the park's highest hill. Since the cars were designed to carry two passengers, many couples found the ride offered a bit of cuddle time along with a minute of thrills.

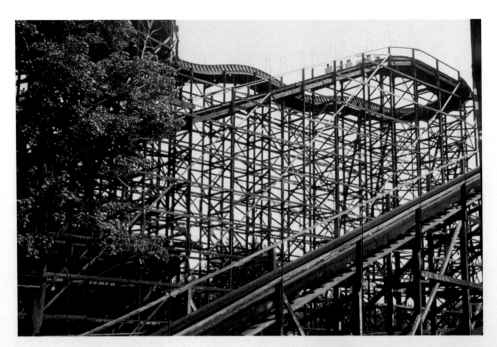

Once the Flying Turns car had been hoisted to the top of the first hill, gravity took over. After a brief undulating start, speed rapidly increased, and the car went barreling from side to side as it negotiated the hair-pin curves of the toboggan-like tube.

It was the curving, twisting chute that made the Flying Turns such an exciting ride. While there were toboggan rides in other parks, the consensus gives the highest marks to the Euclid Beach version.

Patrons are lined up for their ride on the Thriller.
The Thriller arguably was the Beach's most popular ride.

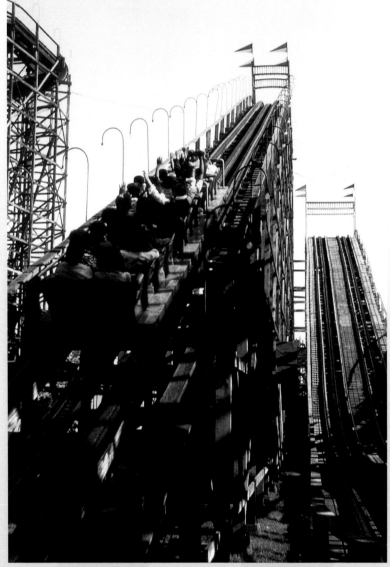

A fully loaded Thriller car has just left the
starting platform and latched onto the chain
that will pull it to the top of the first hill.

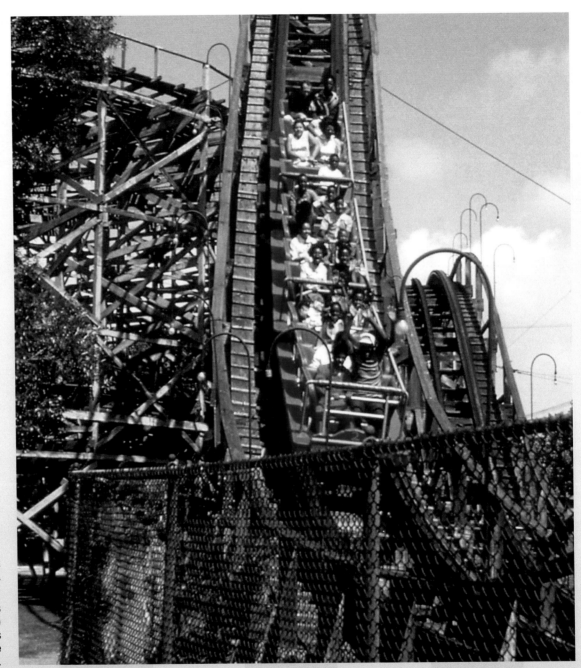

A Thriller car charges down the first hill. What Thriller patrons probably remember most about the ride, however, was the series of small hills (one is seen to the right) which provided passengers with ample "air time" as the car raced to the exit platform.

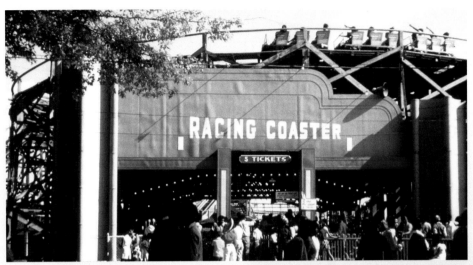

The Racing Coaster was the Beach's oldest surviving roller coaster, dating from 1913.

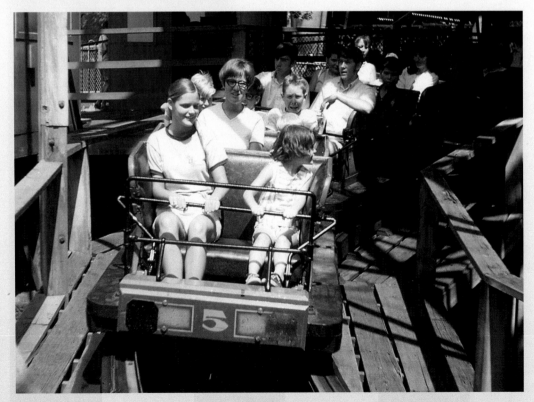

A Racing Coaster car leaves the starting gate. Two cars, on separate tracks, were dispatched at the same time. Riders not only had the thrill of the ride's hills and curves, but also the fun of being in a race to see which car would make it to the finish line first.

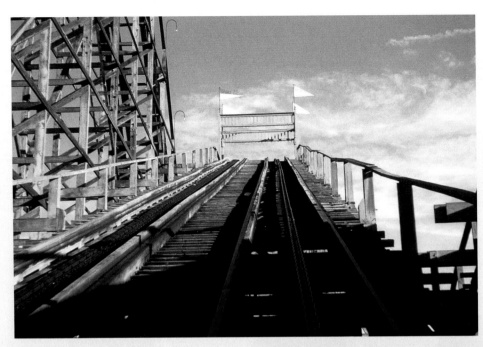

The Racing Coaster was double-tracked throughout. The cars were hoisted to the top of the first hill—and then the race was on.

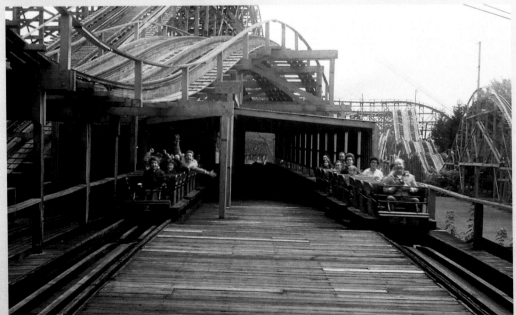

A passenger in the red car on the left raises his arms in jubilation, but as the photo indicates, it was the green car that actually won the race.

A WINTER TALE

On September 28, 1969, Euclid Beach Park closed its gates for the last time. The sounds of summer were silenced, and the sycamores began to shed their leaves. Before long, snow blanketed the park.

On the surface, winter 1969 did not appear much different from all the winters which had preceded it. But it was different.

The arrival of spring would not bring a renewal of activity. There would be no scurrying to make sure all was ready for another wave of visitors. No one would again post a sign that read Euclid Beach Park is "Open for the Season."

That winter brought with it one last reminder of the wonder that was Euclid Beach Park. It was beautiful to see, but painful to contemplate.

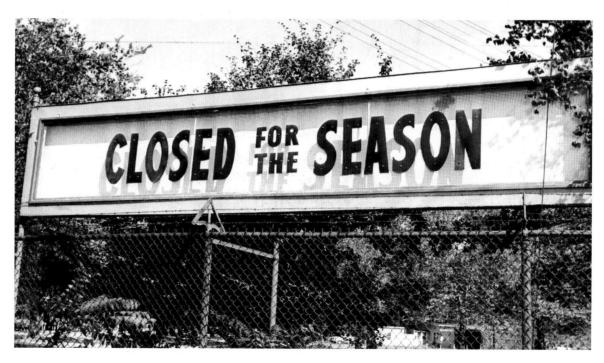

The "Closed for the Season" sign went up at the end of September 1969. This time, however, a different sign would have better told the story: "Closed for all Seasons."

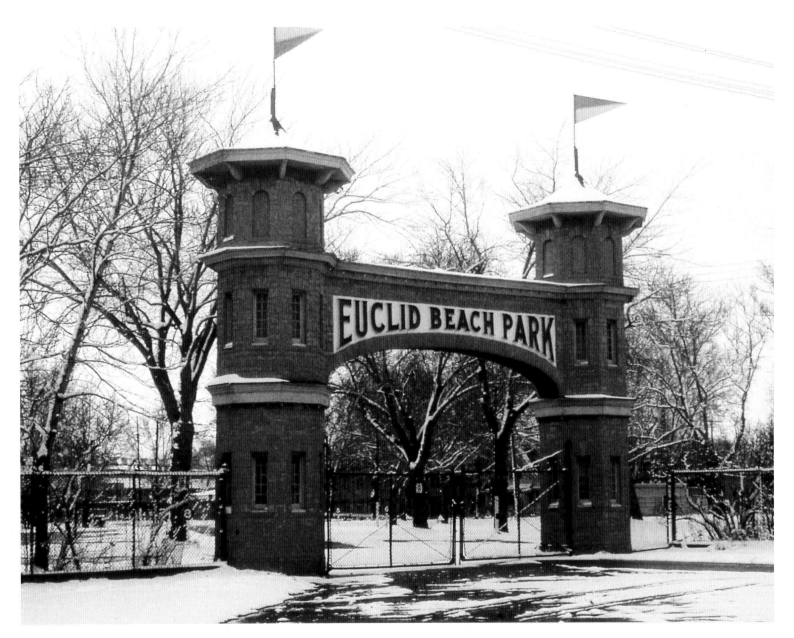

A dusting of snow adorns the famed Arch. The gate is closed and padlocked.

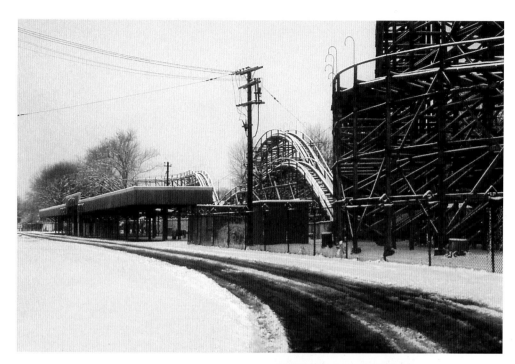

The bus loop looks forlorn with its coating of snow. The Thriller hills form the backdrop.

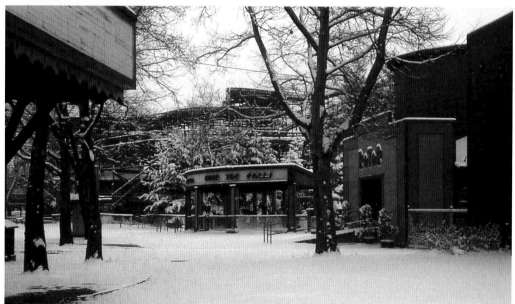

The midway is hauntingly beautiful with its cover of snow. The view looks toward the east.

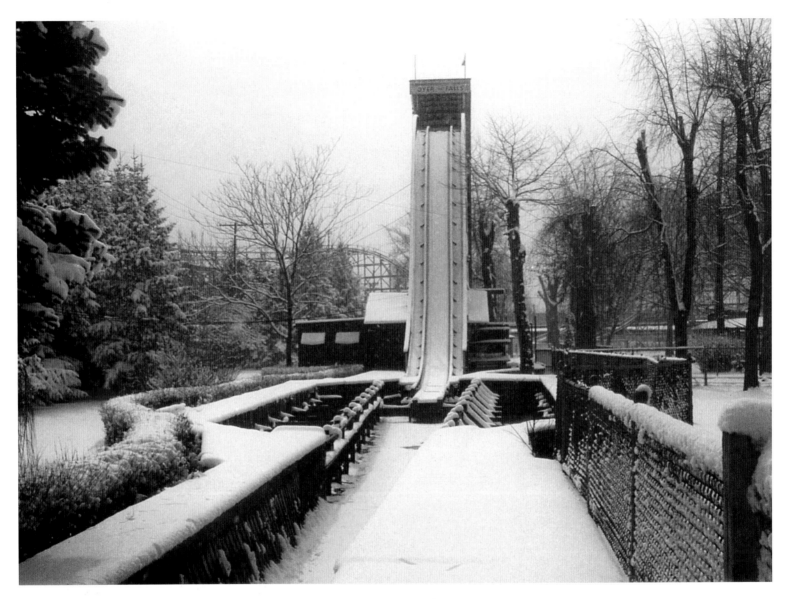

Snow has replaced the water in the Over the Falls trough.

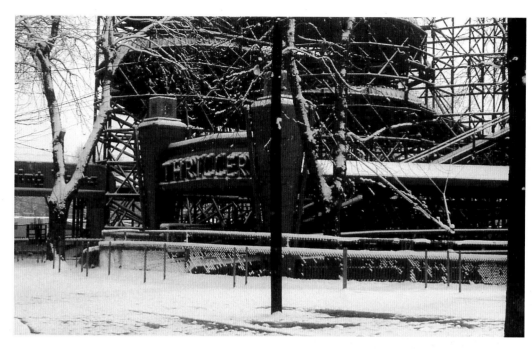

No passengers wait in the snowy entrance queue at the Thriller.

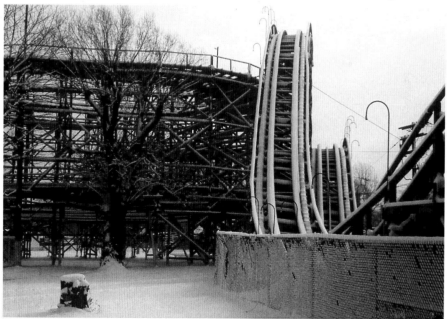

The Thriller's hills are coated with ice and snow.

The Carrousel building is empty. The ride has been taken down and disassembled for shipping to Old Orchard Lake Park in Maine.

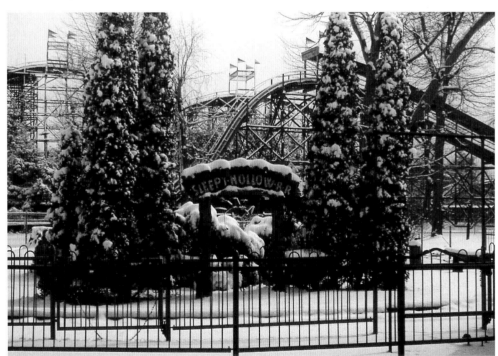

The Sleepy Hollow Railroad home station platform is snow covered. No one is out walking in this winter wonderland.

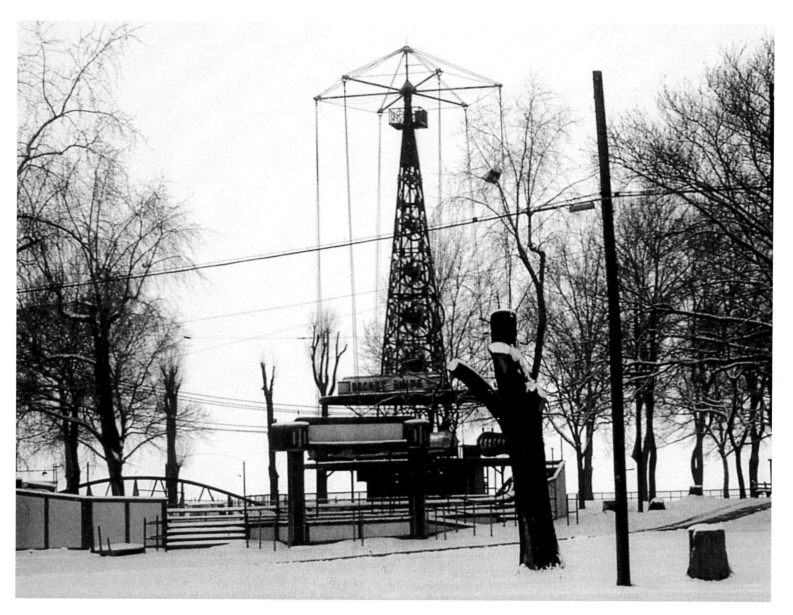

The sign for the Bug is gone, and so are its cars. The rocket ships are at rest above their boarding platform.

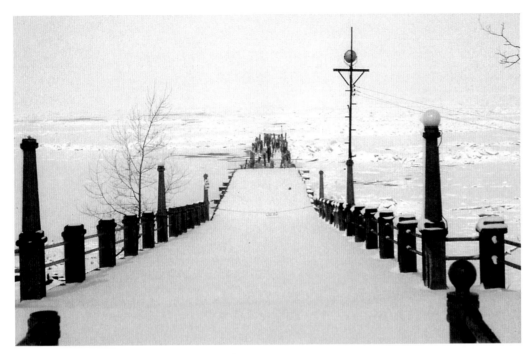

Lake Erie is ice covered, and the pier shows how much damage the lake in winter can do.

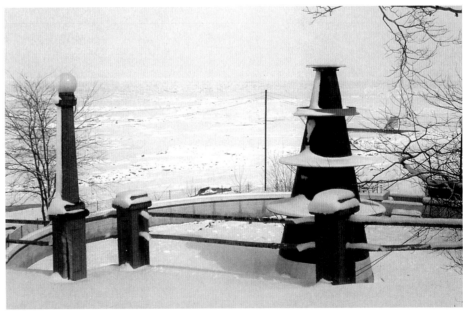

The fountain stands silent above the frozen lake. It will never flow again.

THE PARK DISAPPEARS

After the park's closing in September 1969, the park's infrastructure remained largely the same. Through 1970, although some of the smaller rides were taken apart and put into storage, the buildings and the high rides remained intact.

In fact, on August 29, 1970, the doors of the Dance Hall opened one last time. The new owners of the park, Associated Estates principals Carl Milstein, Robert Stakich, and Dominic Visconsi, held a farewell dance. About 1,000 people attended the event and danced to the music of Hank Geer's Orchestra.

But then the vandals could resist no longer. The empty wooden buildings were irresistible to the arsonist. The first fire leveled the Log Cabin in May 1971. Thanksgiving time saw the torch applied to the Theatre Building. Right after Christmas 1971, the Surprise House was burnt to the ground. The fires were moving closer to the Campgrounds, and residents became increasingly concerned.

The last fire, and the one that spelled the end for the remaining structures, leveled the Dance Hall. That occurred on February 23, 1972. Two days later the bulldozers moved in and began the final demolition of Euclid Beach Park.

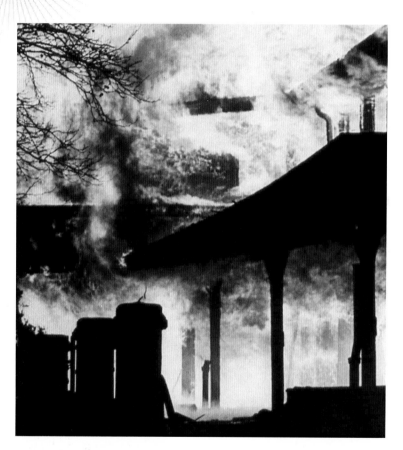

The night is illuminated by the fires that consume the Euclid Beach Dance Hall. *Cleveland* Press *photo, Special Collections, Cleveland State University Michael Schwartz Library*

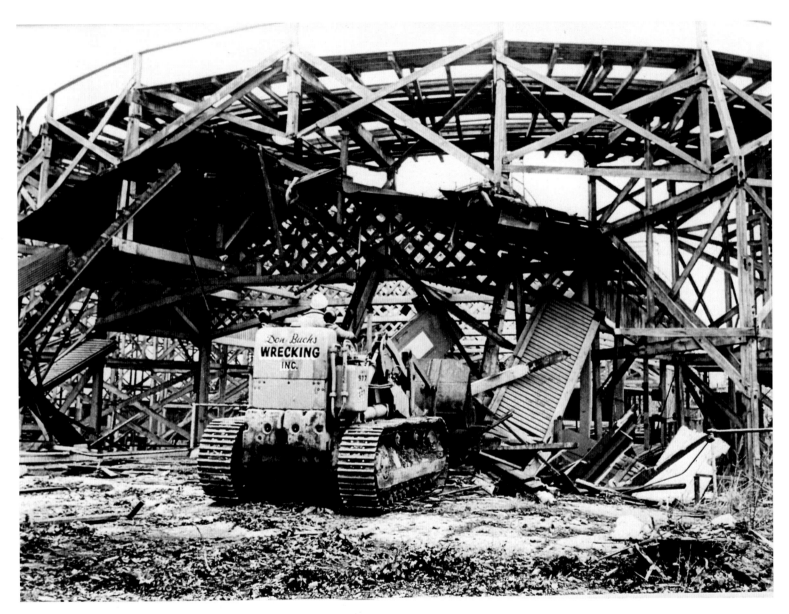

A bulldozer bites into the boarding platform of the Racing Coaster in February 1972.

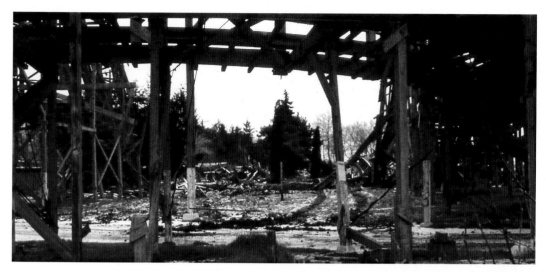

All that remains of the Racing Coaster is the back turn. The rest of the ride is already down.

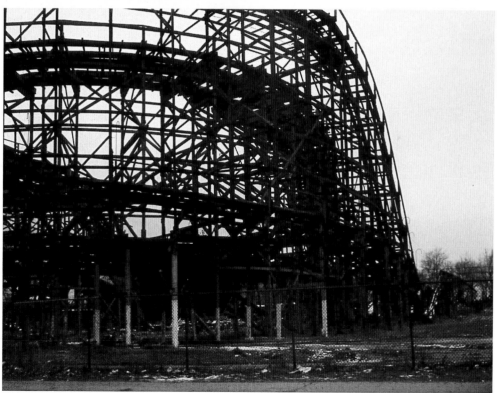

The Thriller was the next to fall. The part of the ride nearest to the midway has been demolished; the outer hills will be next.

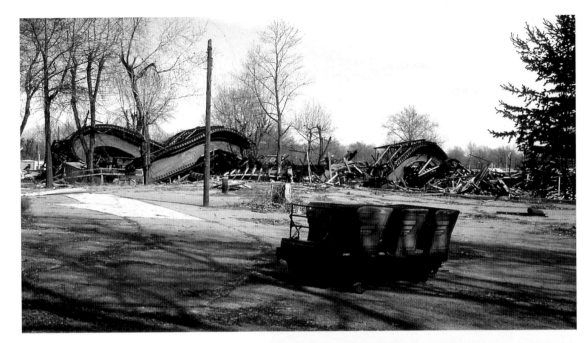

A Racing Coaster car rests forlornly in the midway, its former home base only a pile of rubble. Debris from the Flying Turns can be seen in the background.

The sycamores have not been pruned, and the grass has not been cut. Except for some debris, the midway is empty.

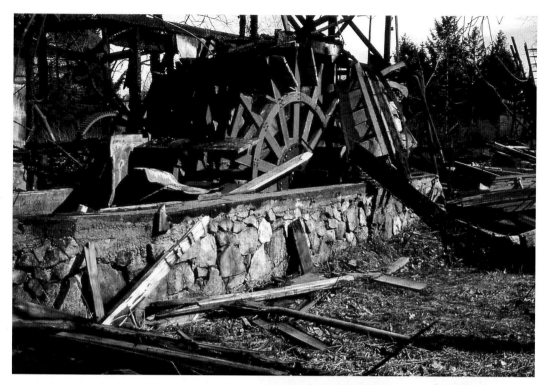

Little is left of the Over the Falls ride. The water wheel, though, has withstood the first assault of the demolition squad.

The Scrambler is long gone, but its operator stand remains, resisting the wildly growing vegetation.

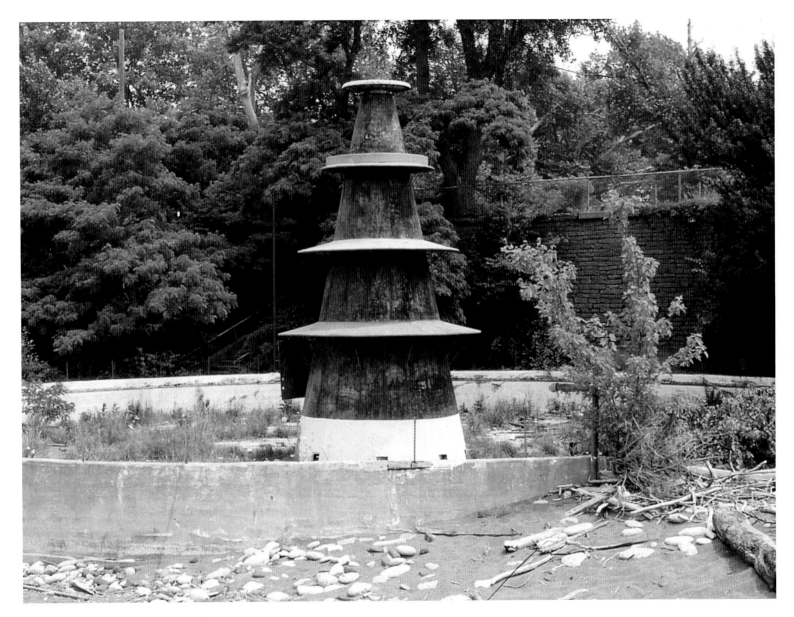

Paint peels from the lakefront fountain, its pool overgrown with weeds.

LAST THOUGHTS ... LASTING THOUGHTS

The ranks of those who spent time in Euclid Beach Park, who remember its rides, games, and food, are shrinking. In another 41 years there will be very few left for whom those are real memories.

But that does not really lessen the significance of the Beach. The Park reminds us of the importance of urban centers having and keeping those kinds of amenities which enrich the quality of life. As much as for any other reason, Euclid Beach Park fell victim to the exodus to the suburbs and exurbs beyond.

Sociologists tells us that a vigorous region needs a healthy center city, and Euclid Beach reminds us that urban assets can wither away if they are not supported. So while the park is gone and memories of it are fading, its history cautions and exhorts us to support what we still have, our theatres, museums, sports teams, and other entertainment venues, lest they too disappear.

Whether one ever visited the Beach or not, we are all a little bit poorer that Euclid Beach Park is gone. It was a wonderful place.

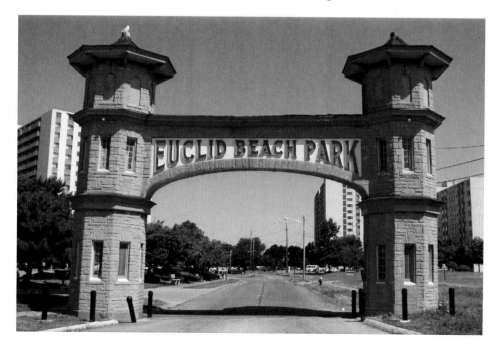

A view of the Euclid Beach Park arch as it appears in 2010. *John Yasenosky, III, photo*